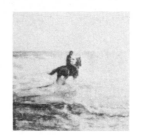

Instant Photo
Instant Art

Instant Photo
Instant Art

**THE NEW SIMPLE TECHNIQUE THAT TURNS SX-70
POLAROID PHOTOS INTO BEAUTIFUL FRAMEABLE PAINTINGS**

BY DOMINIC SICILIA

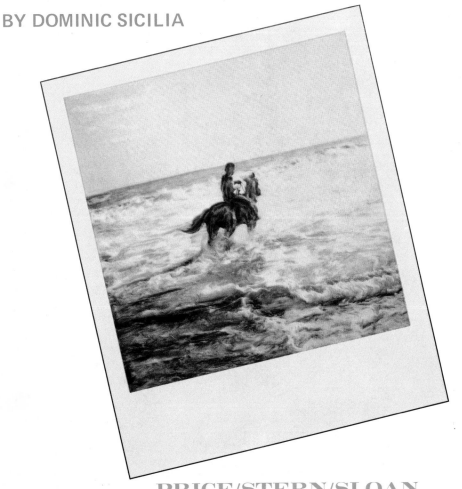

PRICE/STERN/SLOAN
Publishers, Inc., Los Angeles

Produced by Dominic Sicilia
and Gail Sicilia

Designed by Lawrence Sloan

NOTICE

The SX-70 emulsion which is manipulated to create Polaroid paintings, as explained in *Instant Photo/Instant Art*, is made of chemical material and care should be taken not to pierce the plastic coating. It is extremely unlikely that the film's surface will break by using any of the techniques described in this book. However, since the following legend is printed on all packs of Polaroid SX-70 film, it is reprinted here for your information:

"CAUTION. Do not cut or take apart pictures or unexposed film as a small amount of a caustic paste may appear. If the film unit becomes damaged and paste appears, avoid contact and keep from children and animals. Should some of this paste get on any part of your body, wipe it off immediately and wash with water to avoid an alkali burn."

INTRODUCTION

Salvador Dali has always been my favorite painter. When I first tried oil painting, I realized even more about his technical brilliance. I'm moved by both Dali's mental concepts and his striking interpretation of them on canvas. He possesses a brilliant eye and a cosmically tuned hand. Yet Dali worked for years to develop his gifts. Because of the great amount of study and practice required to develop even a passable artist's hand, I gave up the thought of ever painting seriously. It was too much time, work and turpentine.

In 1973, I bought one of Polaroid's new SX-70 cameras. It is an amazing machine, spitting out slickly packaged photographs that let you see the development process in minutes. The fact that the liquid emulsion developer stayed wet for at least five minutes after the photo ejected from the camera suddenly opened up a whole new world of artistic achievement. The results can be seen in the paintings on the following pages. They are SX-70 photos, physically altered into paintings.

What is most satisfying about this process is the easy way it allows anyone to photograph any scene as a potential painting or turn an idea into a photographic reality and in less than 10 minutes without any special tools create a work that could pass for an oil painting.

You'll probably never paint like Dali or van Gogh or Renoir. But you'll find their techniques reflected in this new medium. Here, then, is an opportunity to express yourself beautifully and creatively — and without years of hard work.

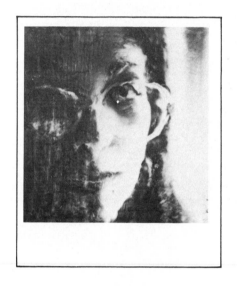

To Gail

CONTENTS

CONTENTS

THE IDEA

The basic principle of Polaroid Painting is the *physical manipulation of the fluid emulsion inside the actual SX-70 Polaroid photograph.* Altering shapes, colors, proportions and lines, and by mixing and moving this emulsion so that the exact photographic line is broken, the impression of a painting is created. What is actually created is both photograph *and* painting.

Polaroid painting is done in two parts:

1. Shooting an expressive photograph, with good composition and visual appeal. (See chapter 5, SUBJECTS.)
2. Heightening the effect of the photograph through manipulation of the emulsion, thus creating an excitingly different painted image. (See chapter 4, TECHNIQUES.)

CHANGING THE IMAGES

Polaroid film develops as a fluid that bears the photographic image you have just exposed onto it. Manipulating this fresh, wet liquid image breaks the sharp and exact photo lines into irregular lines, less true to life, more impressionistic. The Polaroid painter thus adds new touches of expression to the photo.

Using any simple pointed instrument such as a knitting needle or empty ball point pen, pressure and strokes are applied through the clear plastic front of the film, causing a reaction in the images of the picture. With a little practice, you can learn how to alter and move these images with considerable control. Within hours you will be able to create beautiful paintings from your photographs.

THE TOOL

I recommend the common plastic knitting needle as the best generally available tool. Knitting needles are available in most variety and drug stores. I use a size 7 for broad strokes and a size 4 for finer work. I break the needles off to about 6 inches in length for comfort. You should experiment for your own style and comfort. Ideally, you should be able to handle it like a pencil or pen. In fact, a dried-up ball point pen is a good painting tool.

THE WORK SURFACE

Work on a clean, smooth, fairly hard surface. Too hard a surface can break the emulsion too radically. A softer surface (like a book or magazine) pads the stylus action, softening the stroke. When traveling I use the back of my Polaroid camera.

THE BANJOIST — This painting was achieved by repeatedly rub a knitting needle gently across the face of the photo, horizontally, then vertically. This is a foolproof to create your first Instant Art pain

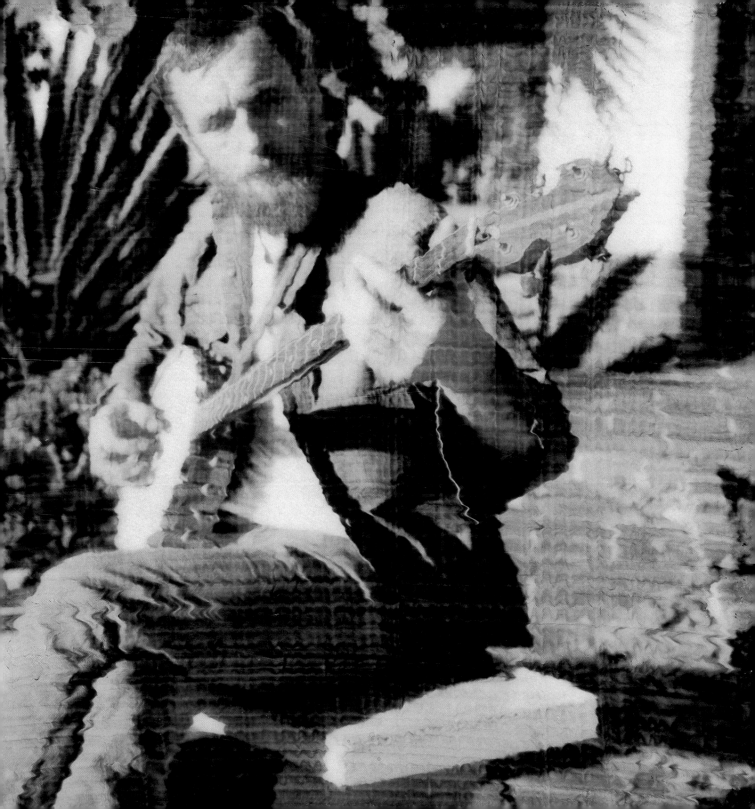

YOUR CANVAS

The most wonderful aspect of Polaroid painting is that practically anyone can cover his "canvas," a 3-1/4" x 3-3/8" SX-70 photo, with a desired scene or image, and without any previous painting experience create high level oil or acrylic painting techniques.

INSTANT RESULTS

One of the most satisfying aspects of the process is that, like the Polaroid photograph itself, Polaroid painting provides immediate results. The ability to create, see and further manipulate images, then paint simulated oil or acrylic paintings in just minutes, allows rapid and concentrated trial and error learning. You will be able to cram years of eye training into several intensive weeks with your Polaroid camera.

This book will introduce you to the basic techniques of Polaroid painting and explain some of the fine points of self-expression via this exciting new medium. You will learn techniques, the importance of timing your work, choosing the right subjects, and shooting specifically for photo painting.

Polaroid painting will help develop those visual abilities that photography requires, as well as the painter's sense of how to alter reality and create an exciting new visual effect.

PRACTICE PAYS OFF FAST

Polaroid painting does not eliminate the need for a good eye or a good imagination in taking a well composed, interesting photograph. A coordinated eye/hand effort is also important, but easily acquired by most people. A little practice here really pays off.

BLOW-UPS

Enlarging your Polaroid paintings often totally changes their effect. Lines look more like brush strokes. More importantly, people can then relate to them as paintings.

Polaroid will make inexpensive, good quality blow-ups, as large as 11" x 11". Your prints will look as much like paintings as the enlarged color prints in this book. Enlargements are perfect for home decor and they make wonderful, personal gifts.

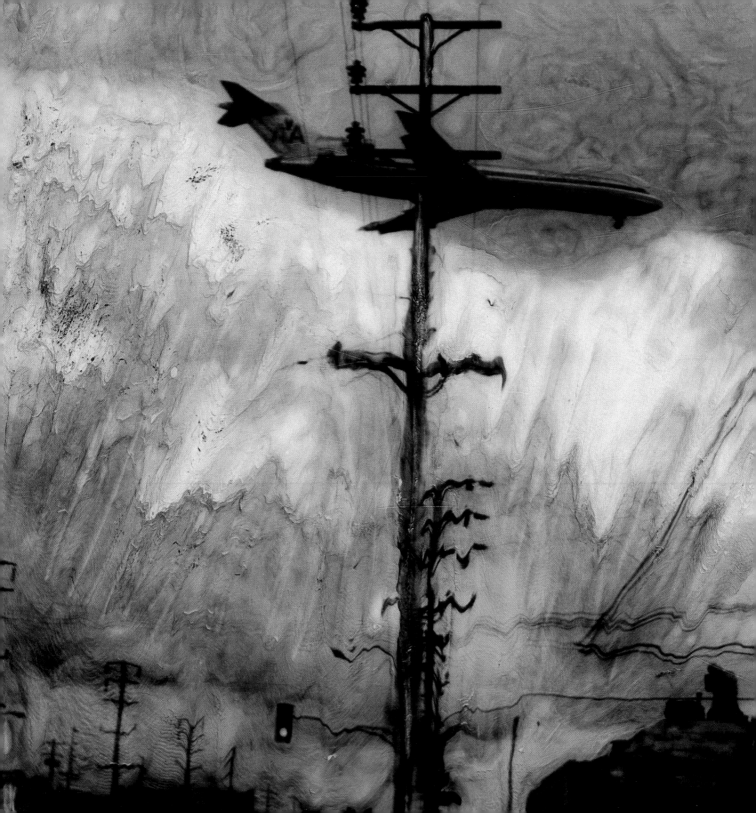

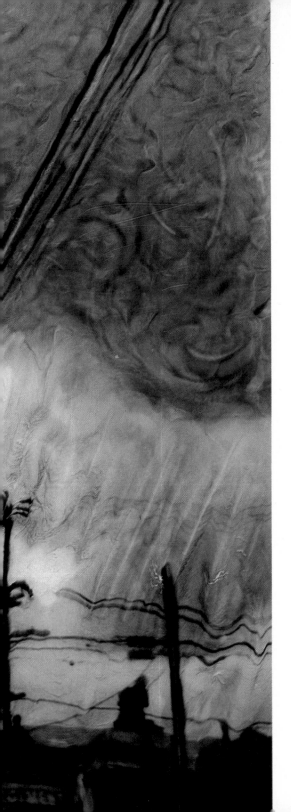

AIRPORT BLUES — Here's a magic moment, provided
particularly by the position of the plane in relation to the tele-
phone pole. The gray clouds became blue on the bluish film,
creating an interesting monotone. The curved strokes in the
clouds create a dramatic effect against the vertical rays painted
into the lighter areas.

PAINT FOR RELAXATION

Polaroid painting, in my experience, is as relaxing as oil painting. It's simple and fast, yet it can provide high level expression and hours of creative enjoyment.

BEFORE YOU START

Before your own actual painting, let me suggest that you look very closely at the paintings in this book and the stroke illustrations provided with several of them. Look for natural stroke lines, try to understand the manipulations and distortions in the context of the Polaroid painting effect.

THE BASIC POLAROID PHOTOGRAPH

A good basic photograph is important for instant photo/instant art painting. Try to get rich colors and patterns. In a short time, you'll begin to see which style of photograph paints the best. Let the paintings in this book guide you. A lot of trial and error time has been spent in finding the type of scenes that work best.

Your natural eye will develop with practice, but by examining your photographs closely, your photo eye will develop even more quickly. You'll learn in time (and in chapter 5), which subjects do not paint well and which do. Filling your frame with paintable material improves the effect of the finished painting. Textures, obvious patterns such as plaid clothing or wood paneling, repetitions in leaves or tiles, etc., paint well. High contrasts of light areas to dark also create excellent paintable subjects.

COMPOSING YOUR CANVAS

Choosing exactly what goes into a photo or painting and where it goes is the essence of your art. You can always find interesting scenes to shoot by simply aiming the camera anywhere. The following procedures should provide the best basic photographs:

A. After deciding on a scene or subject to be shot, look for an angle, a perspective that puts all the best, most interesting and most paintable elements into the picture.

B. Keeping them all in the picture, change the angle so that you see various combinations of these elements. Sometimes you will know what you want, sometimes not. In looking carefully, you will often discover an entirely different perspective.

C. After you find a good angle that presents an interesting subject and is visually attractive, move back and forward on that angle (usually closer) until you see your chosen photo in your viewfinder. Stop to see what you have on your screen. If in doubt, shoot close up, medium and long shots. A little practice in this pays off fast. It is also important to analyze your old photographs for possible angles and distances that might have worked better.

SIR RALPH — An unusual clown, with his white beard and red hearts, almos guaranteed that this face would paint well. The open mouth, left photograph is a great part of the effect. The swirled eyes are important too, and th liquid effect in the beard adds greatly to the confusing photo/paint effec

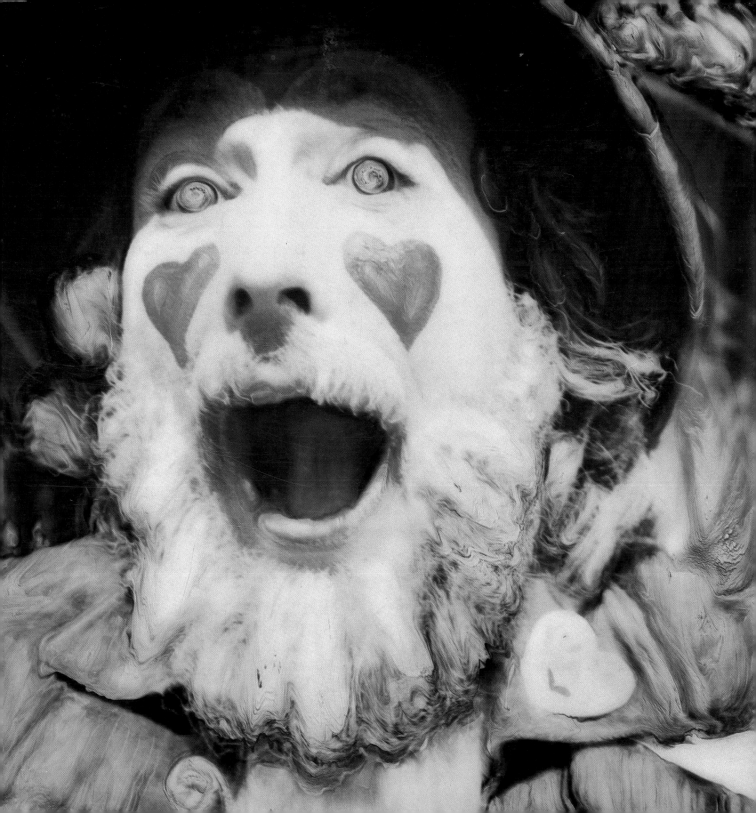

FOCUS FOR PAINTING

In most Polaroid photography, it is best to shoot on one focal plane; that is, to keep all significant objects the same approximate distance from the camera. This keeps all lines equally sharp. However, occasional shots with sharp foreground objects but soft, fuzzy backgrounds can sometimes lend greatly in giving depth to your painting. As a general rule, however, sharp, defined lines will distort better when you begin working with the emulsion.

CONTRAST

I have found that a high contrast, almost severe lighting works best for my basic photograph. Since the interplay of light and dark is the essence of photography as well as painting, providing these contrasts for your SX-70 photograph is important. An occasional subdued light picture may provide an interesting effect, but as a general rule, such shots do not make striking paintings. *This is probably the single most important factor in creating paintable photographs.*

LIGHT

It is important to note that the fluidity of the photo emulsion between the plastic sheets of the Polaroid print varies according to the light value of the scene. Black and very dark colors provide the least liquid. The area is paintable but in the manner of chalk on a blackboard, rather than paint.

Scenes that are too light, especially white, are very fluid, but create bad paint lines when manipulated. Therefore, it is best to avoid over-exposure and large, light areas.

Late afternoon, with a warm sun lighting from the side, is probably the best time for shooting. Sunrise and early morning lighting can also be effective, but the colors tend to be colder. Hot colors make hotter, richer paintings.

THE MAGIC MOMENT

Although composition, focus, contrast and lighting are of prime importance, there is one other vital element: The Magic Moment. In a moving scene, or where there is movement across the film, i.e., passing traffic or at an athletic event, learn to wait for The Magic Moment. First set up your shot, allowing for the magic moment to happen. Then, wait and watch for it. (See page 15.)

Windshield and figures in the car are mildly disguised for effect.

Gentle distortion was the key to this piece. Street, buildings are stroked in natural lines.

Swirling headlights add to surreal effect.

License plate is left photographic. Expanding highlights creates the painted effect.

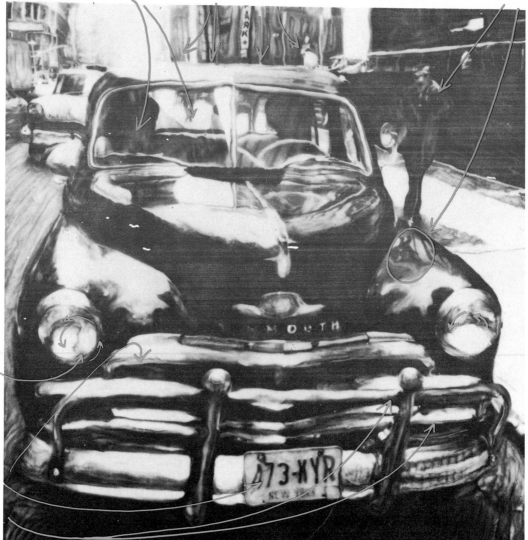

'51 PLYMOUTH — An undistinguished car that gained great image power in the painting. The mysterious but photographic occupants of the car seem sinister. The character on the street has become surrealistic.

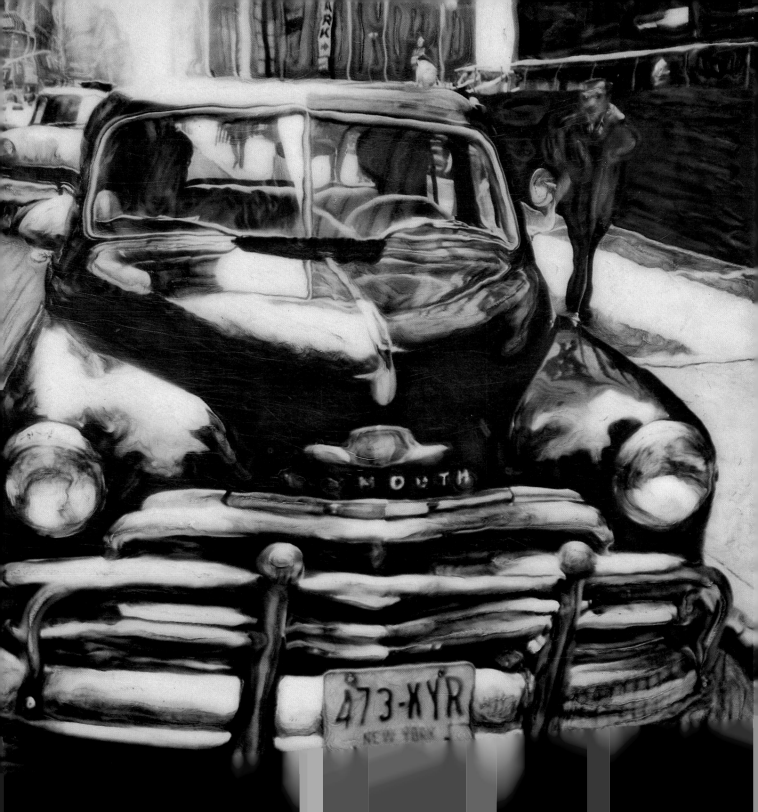

WHEN TO PAINT

You can approach your painting in several ways.

It is wise to keep a stylus in your camera case. In the beginning, you'll find instant art may be the perfect way to save those out-of-focus or badly-colored snapshots which would normally be thrown away. Considering the cost of each SX-70 print, this is a perfect and inexpensive way to experiment with the process.

One important suggestion, particularly if you wish to approach Polaroid painting seriously: Take your time with each attempt. A painter spends hours setting up a canvas and preparing paints and brushes. You have been spared the preparation and the turpentine clean-up, but your painting still deserves adequate time. **Finding the right shot is a major part of the task. After you've found it, paint each photograph individually. You will quickly zero in on the best qualities and painting lines.**

If you don't have a lot of time to work or shoot, do two or three shots in a row. Keep one as a photo reference, paint one immediately, and start to paint the third as soon as possible (within a few minutes). The timing of development creates different qualities in the emulsion movement, but the first shot will familiarize you with the qualities of that particular film.

TIMING YOUR POLAROID PAINTING

The SX-70 developing process takes about five minutes. As the emulsion dries, it becomes less fluid, harder to manipulate. Some batches develop a little slower, some a little faster. (See testing procedures in Chapter 8 to learn more about how to make the timing work for you.)

Since the painting process stops the color development in the areas touched, it is best, for most effects, to wait until the developing process is nearly complete. If you are working in big, broad strokes (see pages 74 and 87) and the looseness of the emulsion is important, you might try starting a little sooner, perhaps 30 seconds or so. The lightness or darkness of the subject matter must be considered in deciding when to start the painting process since lighter colors are more fluid than darker ones.

Clouds in the sky lend interest to this painting. Swirling strokes create movement.

A slight distortion of the windows breaks the photographic look.

The sky was very liquid and took radical strokes, so . . .

long radical strokes completed the painting in the same style.

Stormy sky is blended into windblown tree.

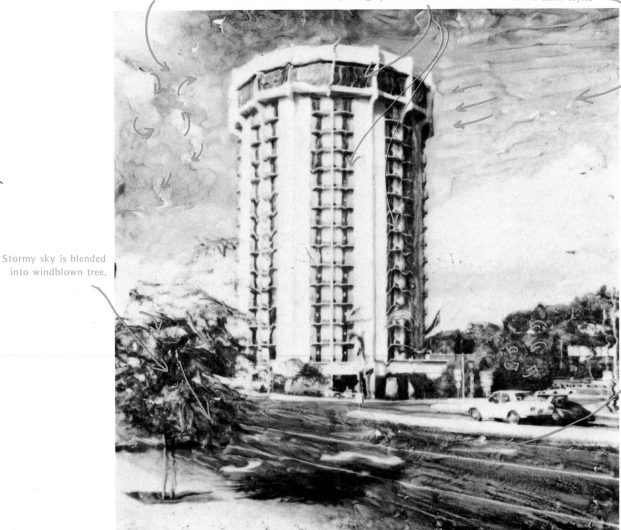

HOLIDAY INN — This came out like an architect's rendering. I started to take this picture about ten different times but couldn't find the right composition. The clouds finally provided the background I was waiting for.

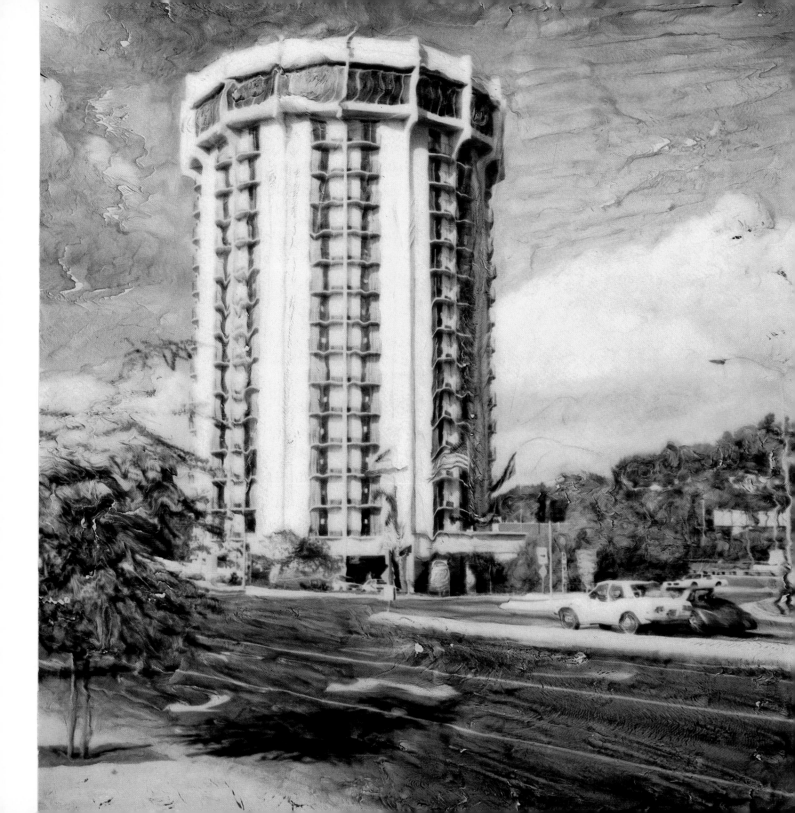

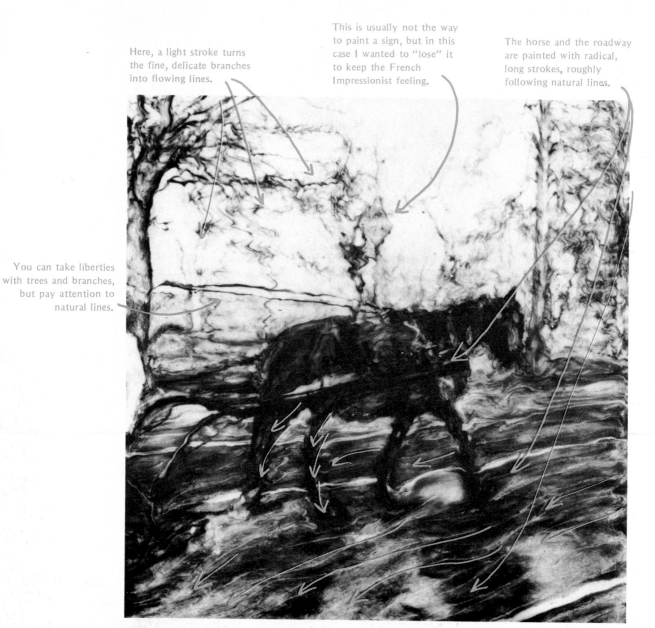

Here, a light stroke turns the fine, delicate branches into flowing lines.

This is usually not the way to paint a sign, but in this case I wanted to "lose" it to keep the French Impressionist feeling.

The horse and the roadway are painted with radical, long strokes, roughly following natural lines.

You can take liberties with trees and branches, but pay attention to natural lines.

RENOIR HORSE — This is a unique piece, very French Impressionist. I traced very loosely, hardly touching the exact lines, such as the horse's legs. But the impressions are intact and the style works.

30

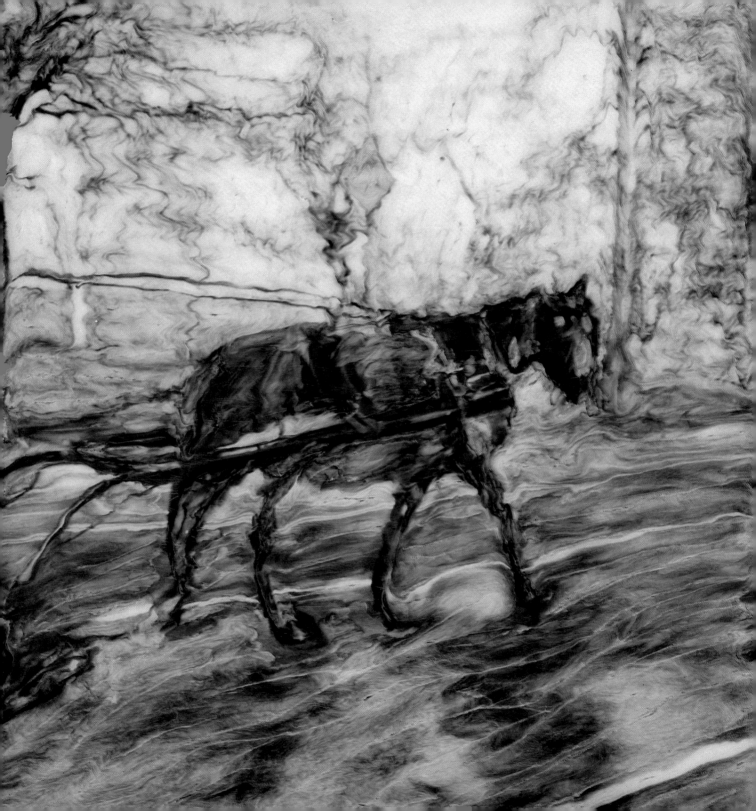

HOW TO DO IT TECHNIQUES/ THE BASIC STROKE

There is only one stroke in this Polaroid painting medium. You use a pointed object as you would use a pencil. By tracing the outlines or rubbing the body of the objects in your photograph, you achieve a painted effect. You can vary the stroke in exactly the same way you would if a Magic Marker were being used. "Brush" marks closely resembling oil painting strokes can be dug into your painting by heavy pressure or coaxed into it with gentle flowing movements. Each photo or image will present a slightly different situation. A little careful practice will show you how to vary the amount of downward pressure needed for the effect you want. How you combine that pressure with the length of your strokes is the essence of control in Polaroid painting. Short (1/4-inch or 1/2-inch hard strokes create a powerful "van Gogh" effect. (See page 79.) Light strokes create softer effects. (See page 62.)

SHAPE, LINE, COLOR

The primary visual/mental key to photographic image versus painted image is the exactness of shape or realism of the photographic object. If the outline or shape of an object appears exact or completely realistic to your eye, your brain says, "It's a photograph." In Polaroid painting, by drawing along the edge of an object, or along any natural lines, you disturb its exact physical shape. Your brain then sees the object as non-photographic, or "painting."

The changing tones of photographic color also lead to this sense of exactness or realism. By gently tracing with your point, you can change the color and the color gradation of objects or backgrounds in your photograph. **This adds greatly to the painted effect. Usually a slight alteration, merely breaking up the sharp, clear outline of an object, will take it from "photograph" to "painting."**

The effect of this change is instant and obvious, but the mental process is worth discussing: Your brain can readily distinguish between a photo and a painting. Where the two are mixed, whether side by side, or superimposed, one on top of the other, your mind receives both messages and clicks back and forth

Follow the natural branch
lines of the palms . . .
and the trees.

A vertical broad stroke
lightens this tree and
moves it towards
the viewer's eye.

These patterns of straight
lines are not natural to
the subject but they
create a great effect.

Entire shadow is left
photographic. The area
stays dark, creating a
depth-enhancing contrast.

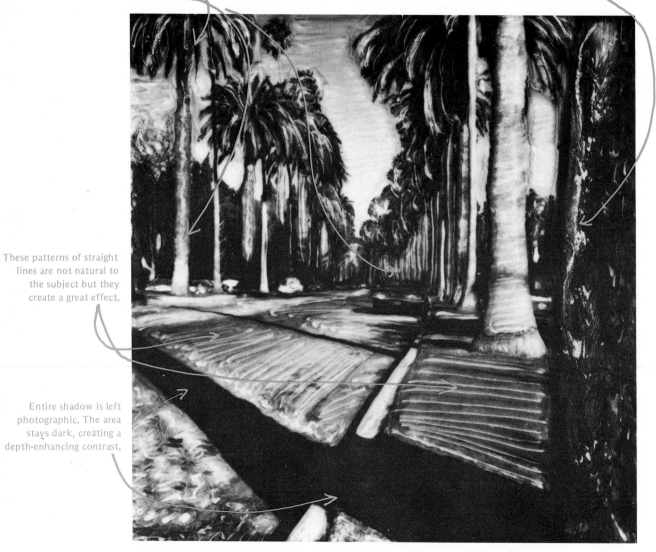

SHADOW PALM — I intended this photograph to be an example of straight line stroking but
the effect was so strong that I've included it here as an example of landscape painting.

34

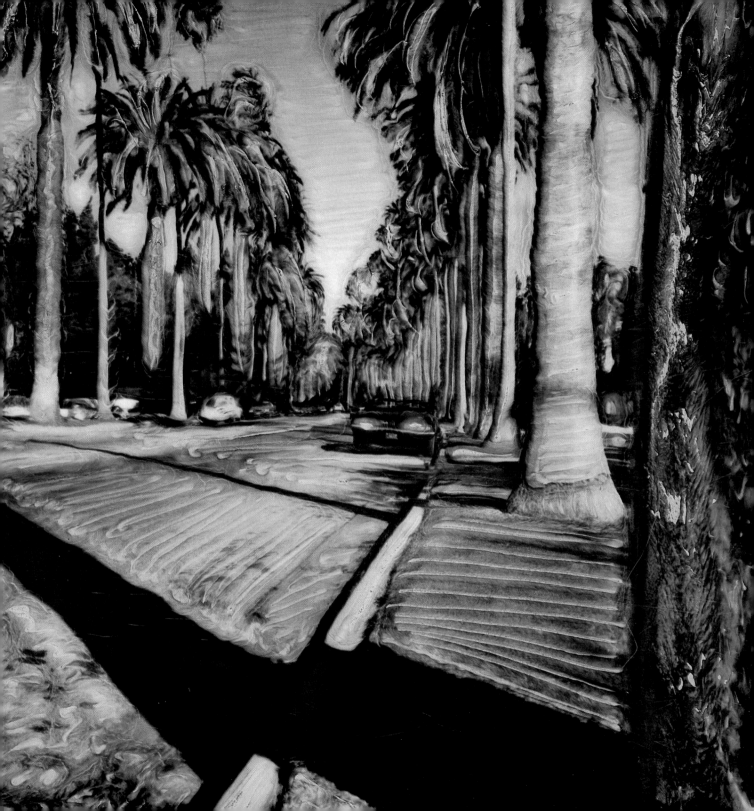

translating and interpreting this information. There are two possible interpretations for your brain to make. One is that you are looking at a photograph. The other is that you are looking at a painting. The conscious confusion can be ignored but the subconscious or subliminal confusion continues to exist. This confusion can create a strange fascination for the painting. This effect is heightened by other changes, such as:

HIGHLIGHTING

This is the effect of expanding by working outward (or, in tight spots, simply pressing straight down) on the bright, highlighted areas in your photo. Loosen the emulsion in the center and gently push it towards the edge. This has two effects. It lightens/ brightens the spot immediately and it alters the outer line of the spot almost unnoticeably, thereby increasing the effect without a noticeable physical shape change. This is one of the easiest of the Polaroid painting techniques. It is also one of the most important. (See page 23 and page 47.)

DRAMATIC CONTRAST

The technique of lightening highlights and other bright areas, and leaving contrasting, darker areas completely photographic also provides very dramatic effects. The eye can even perceive painted images in completely photographic areas adjacent to painted areas. Heavy manipulation also blends colors together, creating streaks and combinations that are totally painted and belie the other photographic aspects of the picture.

COLOR AND CONTRAST

Manipulation lightens the "painted" area and you can, of course, control the degree of lightening. When the contrast between a dark and a light area is altered, the photo is then interpreted by your brain as a painting.

With a little luck and/or skill, you can actually shift certain colors and pigments from one area to another. However, this technique works best with abstract-type paintings. It is usually preferable to work within existing lines, shapes and colors in order to give your painting a more natural look.

SERPENT — This started as a flag shot and some magic movement created the
serpent's shape. A little manipulation gave eyes and a point to its head.
The softer strokes in the sky move the serpent closer to our eye. The
painted buildings frame the scene well.

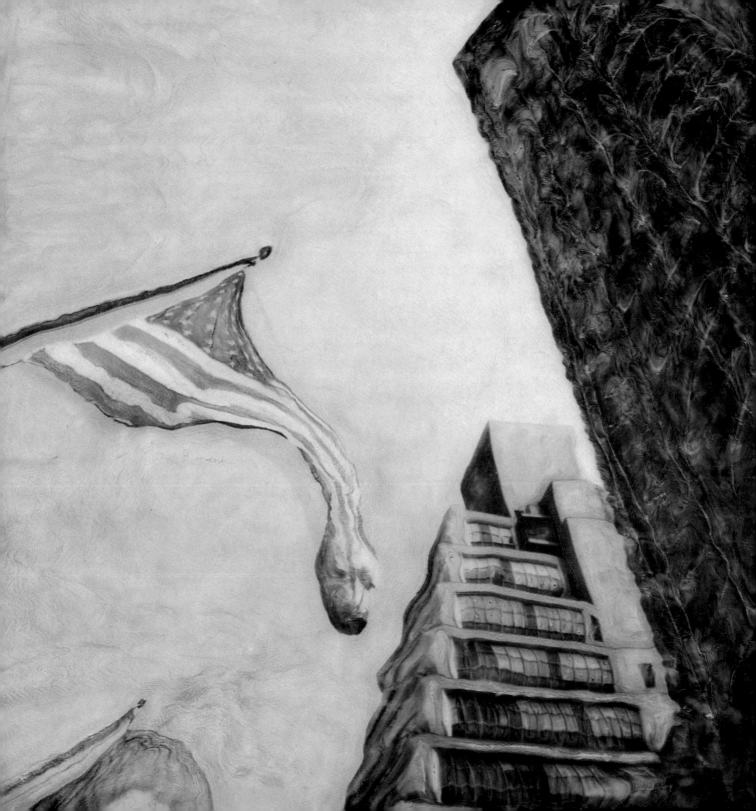

PROPORTION

Your eye allows for lens distortion and *adjusts to interpret a photograph accurately.* In Polaroid painting, it is important to make use of this quality. One very effective technique for fooling the eye very subtly and achieving a strong painted effect is to distort the relationship between the sizes of easily related objects. For example, expanding a car's headlights in relation to the size of the car itself.

This effect is seen most dramatically in expanding eyeballs, headlights, telephone poles, trees, etc.

Proportion alteration is best done in light areas since stylus lines show less. Start in the foreground and work back. That is, start with the objects closest to the camera, and work from the inside, middle of the object, loosening the emulsion with your stylus and pushing outward on the line of the object. Slowly, the object will become enlarged. Continue to push the emulsion gently into the darker areas surrounding it, expanding without losing the outer line edge. It is important to work with the natural direction of the object, i.e., round objects should be worked circularly from the middle out. Horizontal objects should be manipulated horizontally, vertical objects vertically. (Exception: you can work against the natural lines if you mean to abstract the object, to eliminate it completely or to change its meaning in the overall composition.)

ENERGY LINES/
NATURAL DIRECTIONS

The same effect (working an object along its natural lines) applies to the more subtle shapes of the photograph. Swirling surf should be swirled more. (Cover and page 70.) The sun's rays should be lightly manipulated in straight lines away from the sun in their natural direction. Hair should be traced strand by strand and always away from the head. Following this rule will give all your painted photographs a natural flow. (Page 55.)

Areas without clearly defined shapes or patterns can be worked in imaginary patterns that create new lines. For example, an automobile tire might be black and have no lines. By tracing circular cuts into the tire, the form is accentuated *and* a forward motion is created in the visual of the wheel. In the same example, the sun's rays bouncing off a chrome hubcap can be exaggerated with straight strokes in the direction of the rays. It heightens the mental effect of the reflection by giving it more prominence.

EDGING

Where a dark area touches a light area, a slight stroke can alter the look at the edge. Pushing the pigments against each other creates a darker, sharper edge. (See page 66.) An individual, aesthetic judgment will be required for the decision to move light to dark, or vice versa.

You can exaggerate shapes
and attitudes slightly for
unusual effects. Work faces
lightly to avoid ugly gouges.

Obviously photographic
items like these signs
are best left completely
photographic — or just
slightly painted. Be
careful. Test gently with
the stylus.

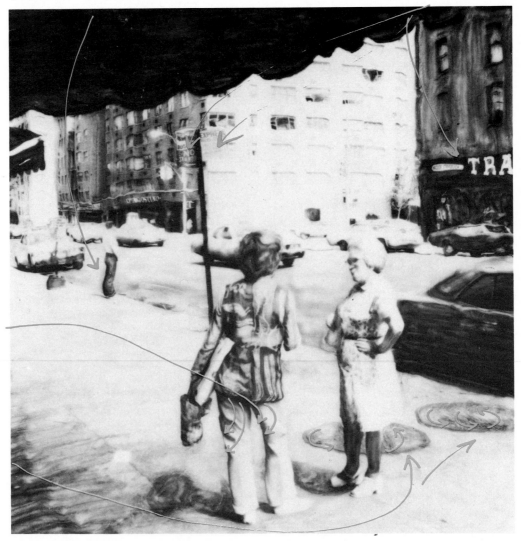

Work dark emulsion to the
edge line, leaving whiter
white areas and darker dark
areas to heighten contrast.
This adds to painted look.

Follow the shape of the
object being painted.
This is an obvious
natural line.

TWO WOMEN ON 72nd STREET — I loved the attitudes of the three figures in this photo. Each section was worked specifically for its lines and paint qualities. People at this size in paintings can be turned into amazing characters (or caricatures).

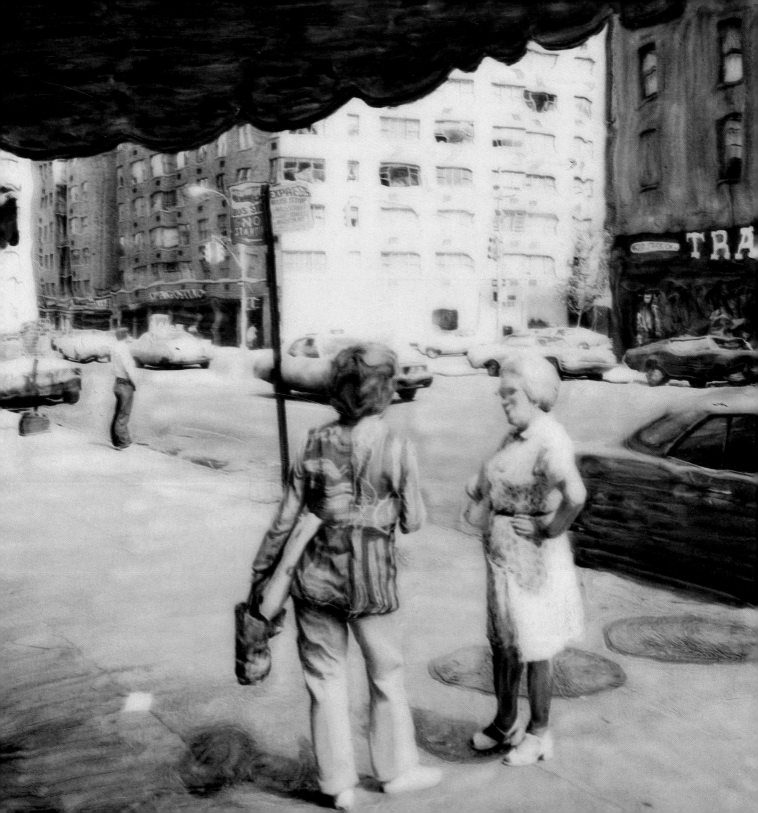

REMOVING IMAGES
OR COLORS

In some cases, you'll find an object, a shape, or a color area that you want to remove in order to improve your composition. When the area to be eliminated is close to the edge, it can be worked under the white edge of the photograph with your stylus. When the area is in the center of the canvas, you can often mix adjacent colors, thus creating an entirely new color. However, this new color will probably be muted by the mixing process.

ARTIFICIAL PATTERNS

It is possible to add interest, energy or elements to your photo/painting by creating new lines, dots, swirls, etc., in photographic areas that will accept the effect of the stylus. (See page 35.)

Sometimes a mediocre piece can be greatly improved by adding a totally painted effect. Your artistic instincts are needed in this area and they will develop as you become more familiar with the medium.

DOTS

By using the tip of your stylus and applying heavy pressure, you can press pin-point dots into your photo and produce still another unusual effect. These can be black dots in light areas (the black plastic back showing through the hole you've pressed into the emulsion), or light dots in dark areas (the lightening effect on the paint). These can often be done hours after the photo was taken, and they are best done last, after the emulsion has set.

At this stage, however, correction is virtually impossible, so it is important to know exactly what effect you desire. The dot technique is particularly good for creating a sparkling kind of activity around other objects and for balancing composition by filling in flat areas. (See page 63.)

LINES

Again, using the tip of your stylus, you can cut lines into areas of your photograph. These can be deeply etched and obvious or gently traced and barely noticeable, producing a subliminal effect. They can be used to create energy lines for impressions or to balance the composition of a less than satisfactory photo.

Lines can be painted early or late in the photo development.

High contrast photo of this bronze statue is painted by expanding the light areas and lightening the high points.

Straight horizontal lines create a wavy pattern as they cross straight vertical lines in background.

By working away from an artificial center, the lines seem to be rays of energy.

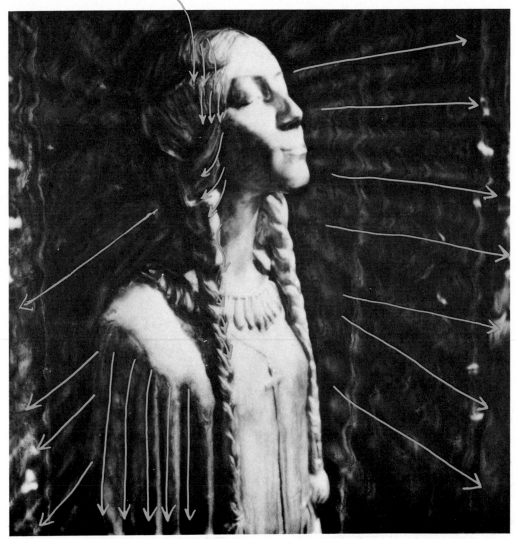

CATHERINE IN BRONZE — This bronze figure graces the door of St. Patrick's Cathedral in New York. The statue was painted by merely brightening the highlights. The rays emanating from the statue were painted in with straight, firm strokes.

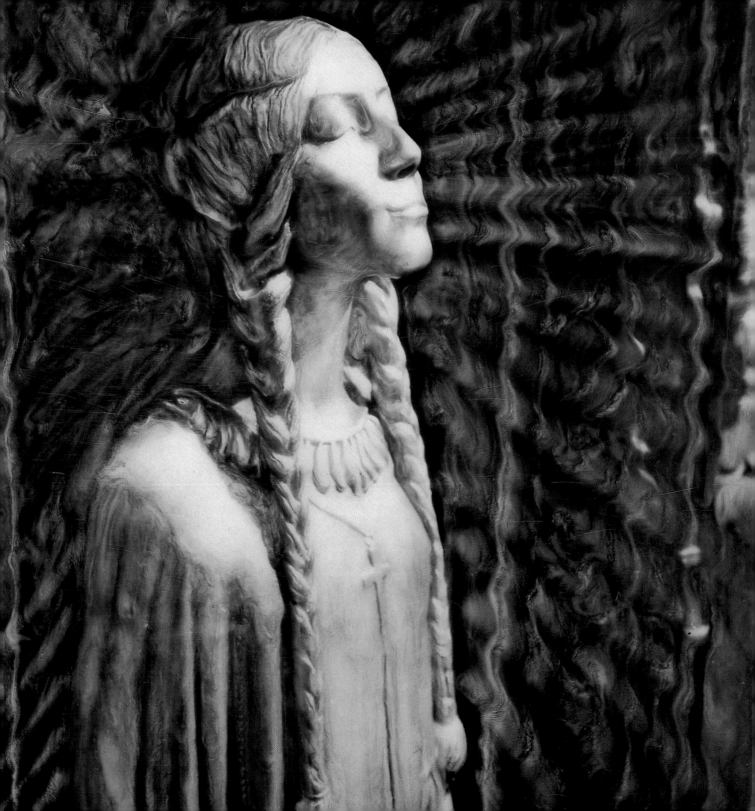

MOVEMENT

If there is any physical movement and in your photo it appears as a blur, you must decide immediately whether to:

1. Leave the blur as a straight photographic image and paint around it.

<div align="center">or</div>

2. Paint the movement to further its effect.

For example: an automobile driving quickly by or a runner in a football game can be painted or left alone. The blurred subject works either way, as a photographic image or as a painted impression. Aesthetic judgment is necessary here and extremely interesting effects can be produced either way.

SMEARING, OR THE PALETTE KNIFE EFFECT

Using the side of the stylus, as a painter uses the flat side of a palette knife, you can move entire fluid areas of the photograph around in unique ways. (See page 51 and page 74.)

This technique can be used for entire paintings. You will find it well worth the time and the possibly wasted prints to experiment and discover when and how to use it.

Smearing works best on very wet, fresh film. The technique can also create unusual effects around other areas which may be purely photographic or perhaps painted in another style. Its best use is in areas without definite lines or direction, where an abstraction will complete the composition of the entire photograph. (See page 87.)

The palette knife technique is difficult and should be used sparingly. Of the hundreds of paintings I've done, only a half dozen are palette-knife style.

The palette-knife or broad, side stroke moved this very fluid photo into a French Impressionist painting.

Swirling strokes create new pattern with tree branches.

The same strokes turn the flat street into a similar pattern as the trees.

Best for tree trunks are simple up and down strokes, expanding them.

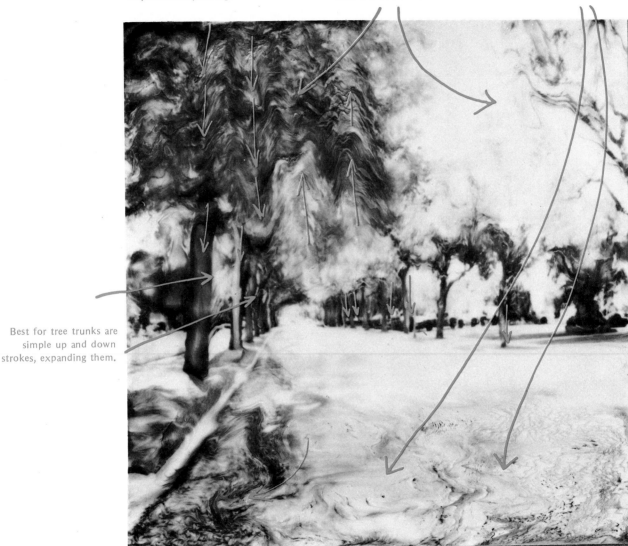

L.A. MANET — Street scenes always work well, but photographs with beautiful autumn colors are particularly effective. This film was very liquid so the many colors could be moved freely with the side of the stylus. The radical swirls create a true painted look.

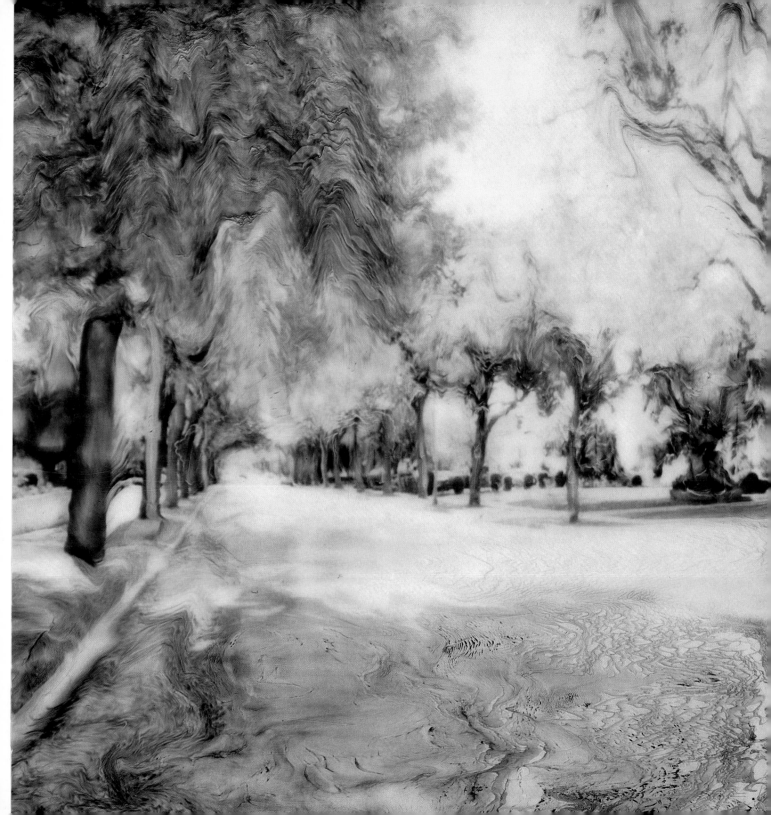

Round objects can be high-
lighted for effect. This one
could be swirled. By tracing
the lighter areas you brighten
and make the nose more
prominent.

For curlier curls, just work
with the natural curvy
direction of the hair.
This is unusual, but
lighter strokes create nice
effects in normal hair too.

Eyes are best expanded.
Whites first, pupils second,
highlights or bright spots last.

Follow pattern lines
of fabric or
other backgrounds.

Generally, I avoid
painting on skin
that is evenly toned.

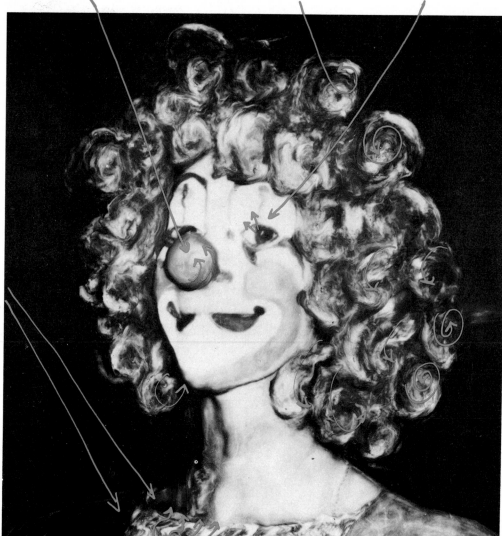

THE CLOWN — The swirled hair and expanded nose created an interesting contrast to the obviously real eyes of this clown. The dark background could have been stroked, dotted or painted in many other ways.

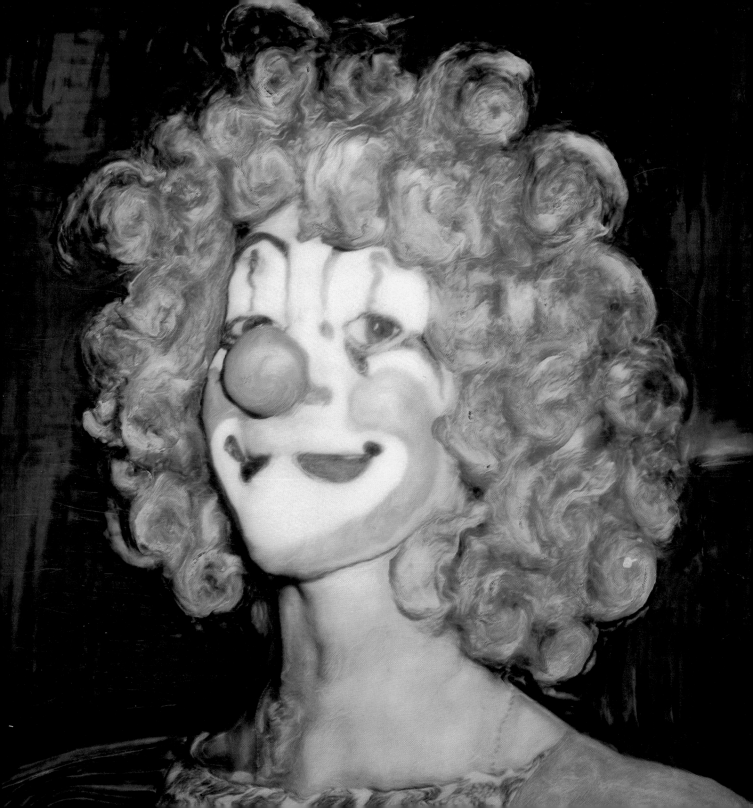

c. *Eyes:* whites can be whitened and enlarged, lending an unrealistic or unphotographic effect. Working with a light touch, expand highlights first, then the whole eye if appropriate.

 Pupils can be swirled, expanded or merely highlighted where there is a hot, white spot. (See page 19.)

d. *Teeth* can be whitened, expanded, or extended. *Lips* can often be pushed back to open a smile, or extended to close one. Work gently and carefully here. (See page 86.)

f. *Ears,* especially lobes, can be expanded and highlighted, providing an excellent effect.

g. *Skin* can be treacherous. It is usually wiser not to risk a great photo by digging into the skin with your stylus. If you wish to try, work gently and carefully.

h. *Hats* help.

3. HOMES AND BUILDINGS

It is best to paint houses as simply as possible, working from the inside out.

a. Expand door and window areas first. Gently. Just enough to loosen the fluid. You can come back and do those areas later.

b. Slightly accentuate the reflective surfaces in windows or on flat areas such as driveways.

c. Gently and easily break the outer line of the building itself. Then brush and rub the bricks or beams or wall sections.

d. Work heavily on the surrounding grounds, trees, or shrubbery. Often it's best to leave shadowed places photographic. But this is an area where you can exaggerate effectively. The contrast of a fully painted tree against a photographic house can be extremely interesting.

e. Be extra careful with smooth skies and fragile clouds. Leave them photographic, or just touch them lightly on the edges.

Simple straight lines in the direction of the drapery can extend the lines into the dark, unlit area.

Hair, eyes and lips high-lighting are just enough to change photographic effect.

Severe, gouged lines following the dress design create the painted effect.

Artificial lines could have been painted into these areas.

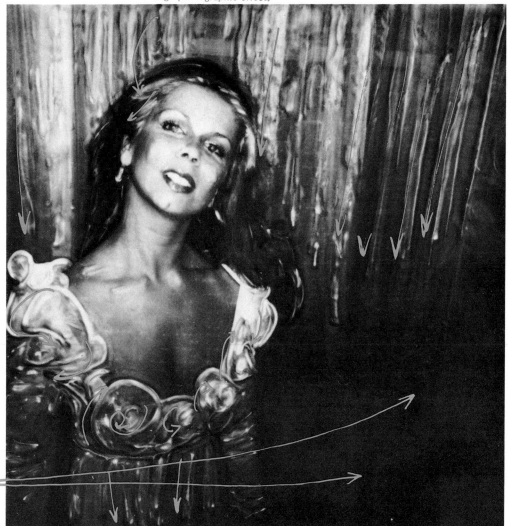

DIANE'S WEDDING — A good example of how a badly exposed snapshot can be turned into an interesting painting. Actually, more painting could have been done, but it was important to leave the face almost untouched in order to provide a hot, focal point. It should also be pointed out that faces are the hardest subjects to paint.

58

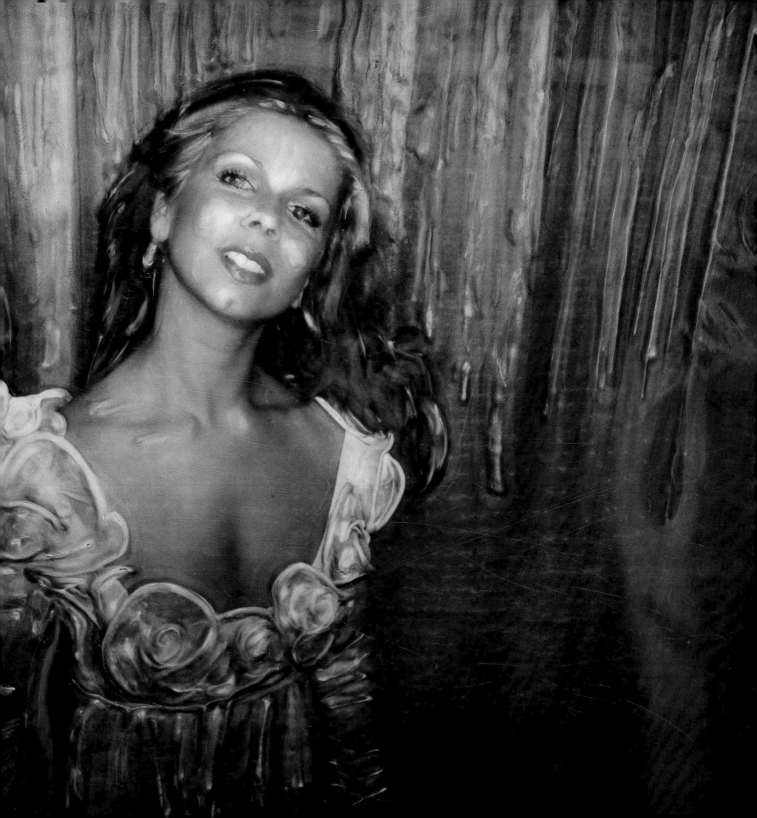

f. Using backlit shots of houses can eliminate the sky/cloud problem and lend an interesting high contrast touch. Coming in closer to the subject can sometimes accomplish the same thing more effectively, providing more paintable surfaces at the same time.

4. AUTOMOBILES

Cars are naturally easy subjects. Car shots with people provide particularly interesting paintings. (See page 23.)

By themselves, car techniques are simple. In fact, the automobile provides good practice for all painting techniques. Follow these rules:

a. Expand and lighten the highlights of reflections on metal surfaces.

b. Expand and brighten chrome areas and white-wall tires.

c. Slightly distort the reflections in the windshield and other windows.

d. Expand headlights (again, working from the inside out, or swirling).

e. Expand the taillights, gently, to keep the red color from getting muddy. This gives exaggerated prominence to that particular area and breaks the photographic reality.

f. If desired, enlarge windows, lights, tires, hubcaps, mirrors, etc., to create a more impressionistic vehicle.

g. Leave shadows on and under the car untouched, dark and photographic. The heightened contrast creates a strong effect.

5. FLOWERS

Flowers and plants (particularly cactus) are natural subjects. Again, work with all natural lines.

a. Expand highlights first, then return to them at the end of painting.

b. Expand the size wherever else it seems desirable to create an impressionistic effect.

c. It is important to learn where not to touch; that is, where the photo already looks like a painting. This will, of course, come with experience.

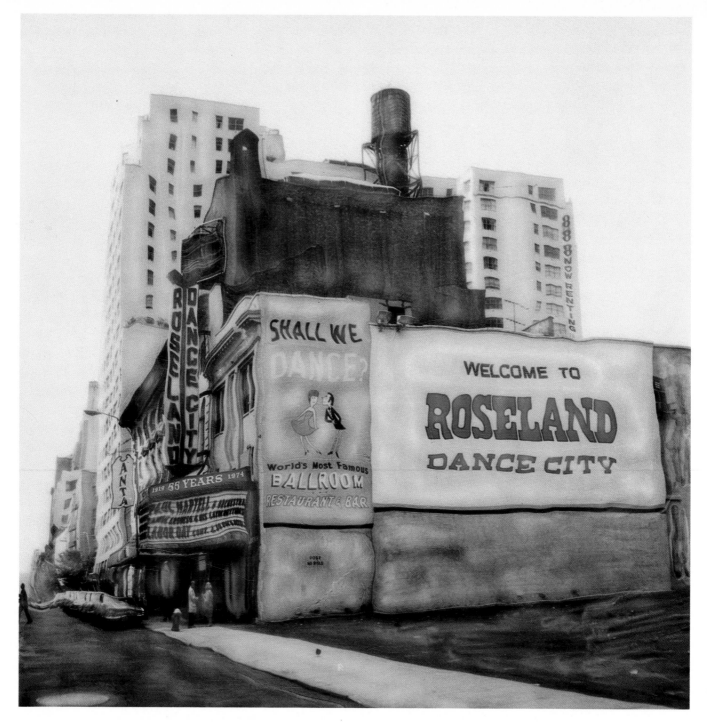

62 **ROSELAND** — A gray New York Sunday. This painting, on the photographic side, is deceptive. It seems to wiggle a bit. This effect is achieved through the use of gentle strokes, by just coaxing a little movement into the paint and onto the scene. It is a good example of leaving the photograph almost intact.

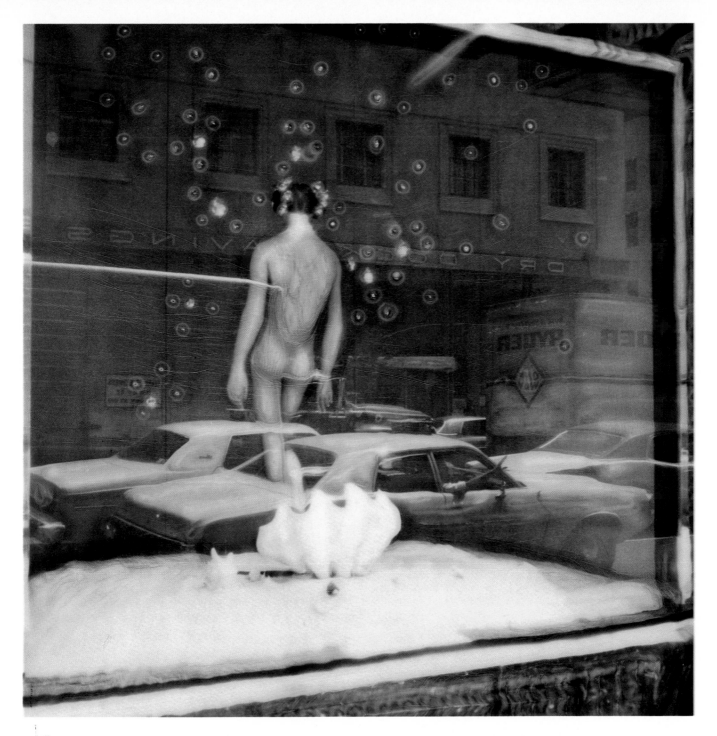

A TAXI FOR VENUS — By highlighting part of the mannequin's leg in this picture, its position relative to the cab was changed. Highlighting the mannequin and the shell project them through the apparent glass towards the viewer's eyes. Dotting the bubbles lends depth to the entire painting.

63

Flowers provide good dot and line subjects, often producing highly unusual effects. (See Techniques.)

6. THE CITY

City scenes (tenement streets, high-rise buildings, heavy traffic, reflective store fronts, moving crowds, etc.) can provide rich canvases. It's easy to fill the frame with exciting subject matter. These shots often work with a good, clear, and recognizable foreground object, such as a fire hydrant, tree, or person. (See page 43.)

Long shots with many directional lines, such as sidewalks, allow you to paint exaggerated depth into your photo. Again, follow the natural lines and patterns.

7. SEASCAPES

The sea, with its exciting wave patterns, already looks like a painting, even in most photographs. Go with the flow.

Surf is fun to paint and hard to spoil, if you follow the natural flow lines. Swirl with it. (See page 70.)

Reflections and highlights should be treated as in all other subjects. Make them pop off the surface by brightening and

expanding them. Work from the inside out of the brightest sections or lines. Enlarge them as much as possible without making it unnatural.

Rocks along the shore should be expanded and highlighted gently so as not to break their lines. Ragged, but clearly defined, edges already have a painted effect, which will add greatly to your work. With rocks, stones, or beams, the edge contrasts should be built up to heighten the painted feeling. A gentle rubbing along the dark edge, just coaxing the dark paint closer to the light, builds the contrast.

Be careful with sand. It is smooth, like skin, and can look very unattractive when manipulated. Footprints, disturbed sand, etc., can be worked along their natural lines and dark edges for great effect. Highlighting works well on sand, but start gently.

8. PEOPLE

A crowd of people in a long or medium-long shot can be an exciting subject to paint. Results are often bizarre, but amazing things can happen to faces, bodies, clothes.
(See page 75.)

Basic advice for people is to start very gently, and work over the area easily several times, rather than trying to move

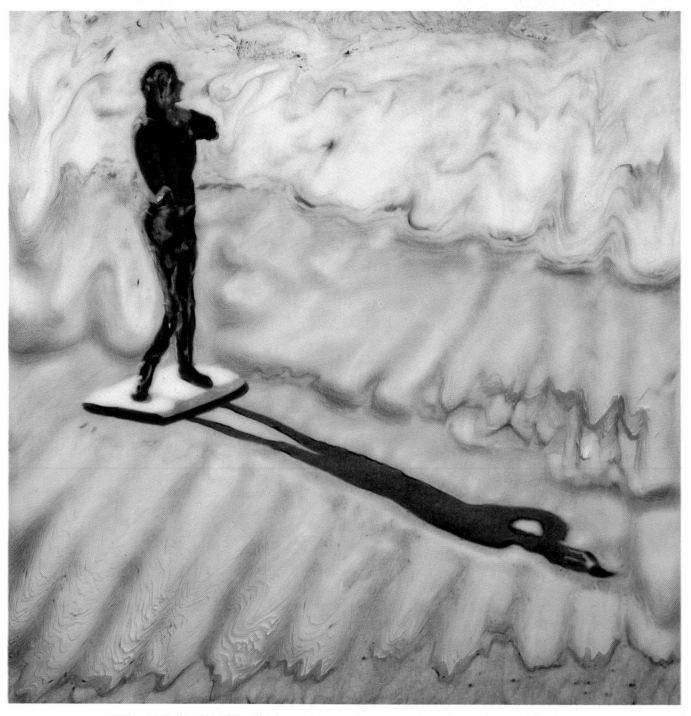

SURFER AT FOUR O'CLOCK — This is one of my favorite pieces, probably because it was the first to come out in Dali-esque style. The painted wet-suited surfer stands on the sand. His shadow remains photographic.

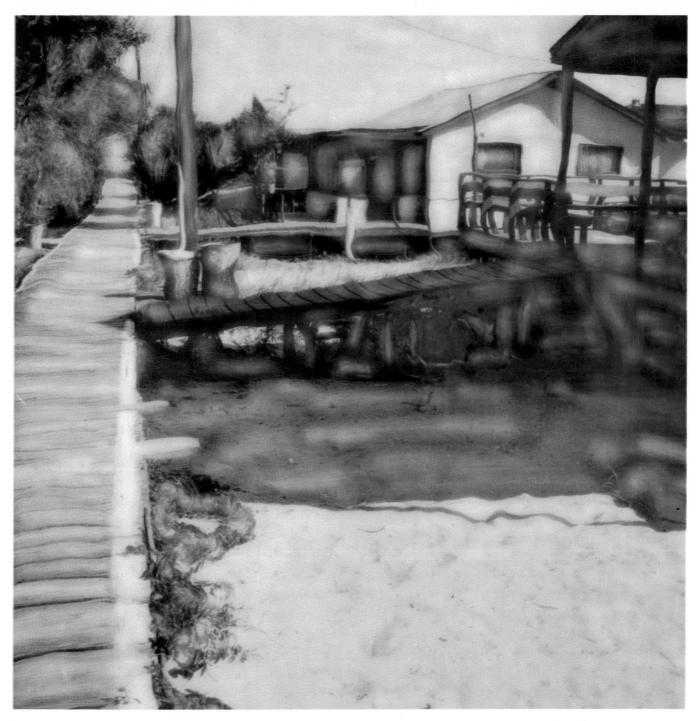

BEACH HOUSE — An ordinary photograph can turn into a lyrical painting with the right softening and subtle highlighting. The exaggerated wooden walkway now leads to a painted area, creating a new effect.

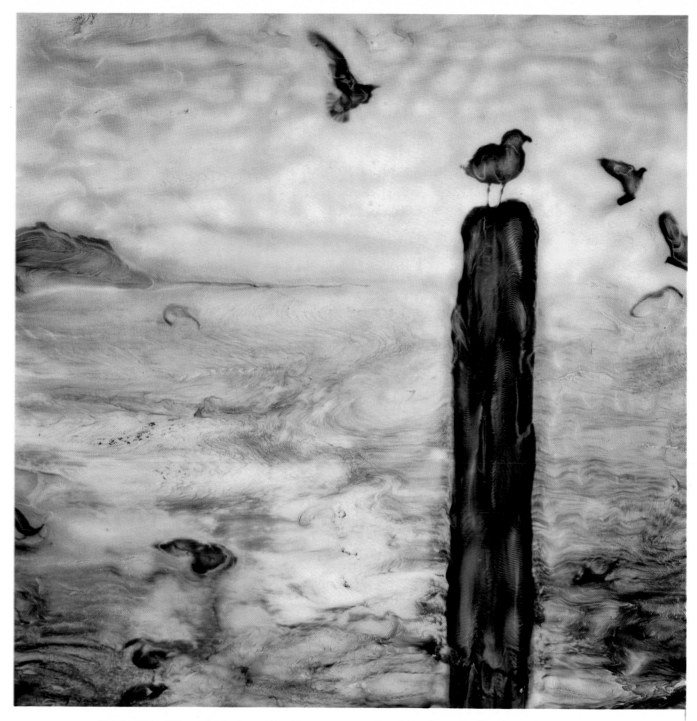

SEA BIRDS — Silhouetted shots, even in a blue monotone such as this, paint easily. The sky strokes are different from the swirls which were added to the surf. Since the main objects of the painting are so easily recognized, the manipulation/distortion can be even more severe — producing an almost rough, oil painted look.

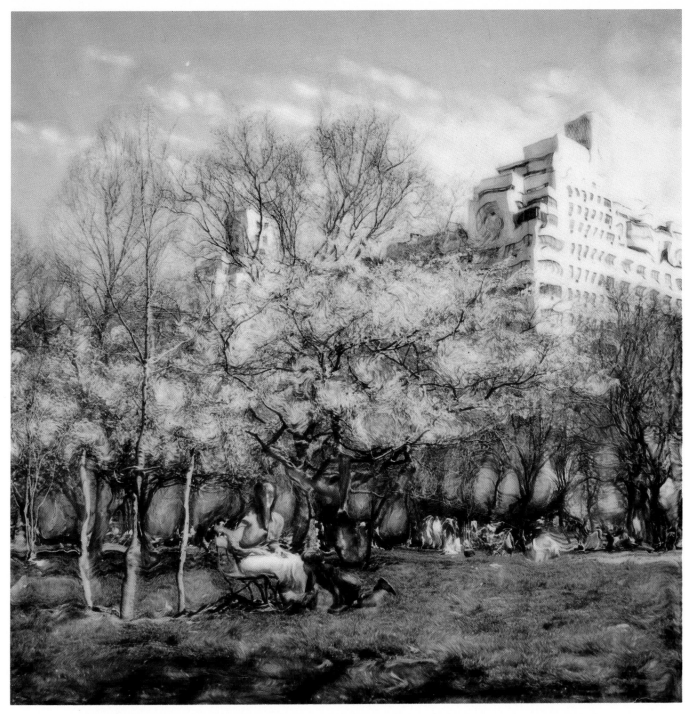

BLOSSOMS IN THE PARK - These Central Park spring blossoms respond to the swirled van Gogh style beautifully. The vague areas between the trees are mysterious and fascinating. The photographic mother and child provide a disturbing contrast to the painted effect.

71

COMBINATIONS

Because you have the ability to change photographic reality into artificial painting, you may want to experiment with mixing objects in your painting. For instance, you could shoot a person holding a photo, or a normally dressed person wearing a mask. In your painting, you can then re-create these items in a new, synthesized way, thus mixing fantasy and reality. Many such surrealistic possibilities can be found.

ACCIDENTS: CREATIVE OPPORTUNITIES?

Aside from the creative aspects of Polaroid painting, these manipulations allow the user of the SX-70 camera to turn the spoiled or perhaps less than satisfactory snapshot into an interesting interpretation of the same subject.

Out-of-focus shots can often be turned into perfect paintings. Blurry background subjects can be painted while the prime subject in focus can be left totally photographic. This can produce a marvelous effect. Work very carefully around an area you want to keep photographic, edging in on it a little at a time.

Unacceptable smiles, closed eyes, or anything else that detracts from a photograph, can often be painted away by instant-art manipulation. Thus, what would normally be photographic discards can now be turned into interesting impressionistic paintings. (See page 59.)

TOO DARK OR TOO LIGHT

Photos that are over-exposed, or over-flashed, or those annoying shots in which you forgot to use a flash, are usually a complete loss. With Polaroid painting, they can be turned into works of art. (See page 75.)

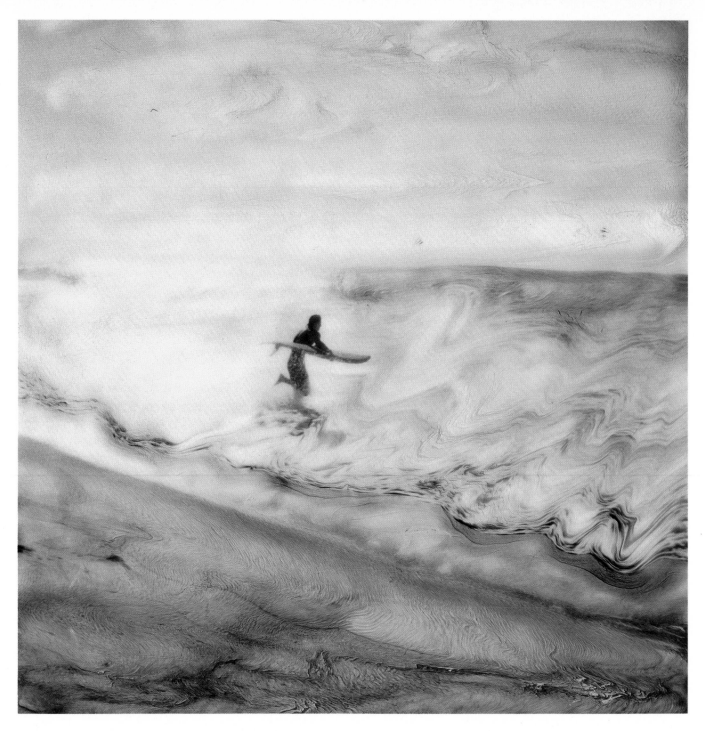

74 RUNNING SURFER — A liquid painting of a liquid subject. The surfer, left completely photographic, provides a central focus. Without the figure, the surf is abstract. This painting was done very quickly, using the side of the stylus in hard, well directed sweeps. This effect is tough to achieve with uniformity.

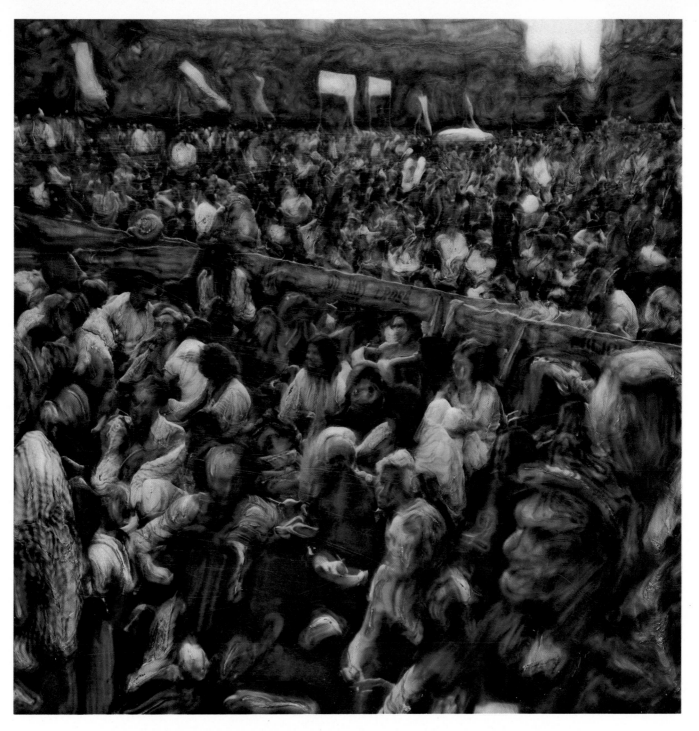

SHEEP MEADOW — Noted photographer Bob Gruen took the photograph. At first I thought it was too dark, but amazing things happened to the faces as the painting process unfolded. Most of the areas were rubbed very gently. The harder lines for definition are minimal. And, of course, some areas were left photographic.

COLOR FLASHES

Light leaks, or strange color effects, will sometimes appear on your print. These irregularities should also be used to create special effects. Where you can do it naturally, take full advantage of it, but where it's not as obvious or simple, it's a good idea to explore the dot and line techniques in an effort to achieve design effects.

HOW TO HANDLE FAILURES

Don't be afraid to do radical strokes on a photo after you've tried to paint it and failed. There's nothing to lose and lots to learn. You might find an entirely new focal point and style and create a great painting.

Often, I'll take a photograph for its own sake. If I love it as a photograph, I'll keep it untouched. If I don't, I'll paint it gently. If I still don't like it, I'll paint it more severely. If that doesn't work, I throw it out. But I've lost nothing, since the original photo wasn't that good to begin with!

There are many opportunities for creative expression and "artistic accident." The skill here, also learned in time, is knowing when to move on and when to stop.

TESTING FILM FOR PAINTABILITY

Stamped on the bottom of each box of Polaroid film is a nine-digit number to identify the batch of film. Different batches have different photographic qualities, and color variations do occur. Some batches don't reproduce red as well as others, so the film may come out slightly bluish and vice versa. Some batches dry faster than others, and must therefore be painted sooner. Some batches are wet and paint well, wet enough to smear. Sometimes, older film is so dry that painting possibilities are very limited.

To make the most of these qualities, it is a good idea to buy only one or two boxes of any particular batch number, and test the first few shots to find out how well it paints. If painting is difficult take snapshots of the kids. If it paints easily, buy more.

You can keep a list of batch numbers and film qualities on the form provided on page 78.

If your film comes out bluish, shoot blue subjects. (It didn't hurt Picasso.) If it's bizarre, either make the most of it or send it back to Polaroid.

BATCH INFORMATION SHEET

DATE	BATCH NUMBER	QUALITIES	WHERE BOUGHT

POLAROID
NEW SX-70 LAND FILM
10 PICTURES, 3⅛ x 3⅛ IN. (8 x 8 CM.)

USE BEFORE

←— Date

←— Batch Number

VAN GOGH FACE — This portrait was made in front of Bloomingdales, one of the
most interesting photo areas in New York for scenes and people. I usually try
not to intrude on people, but the hair, glasses and skin looked so paintable
in this case, that I asked for, and received, permission to make the shot.

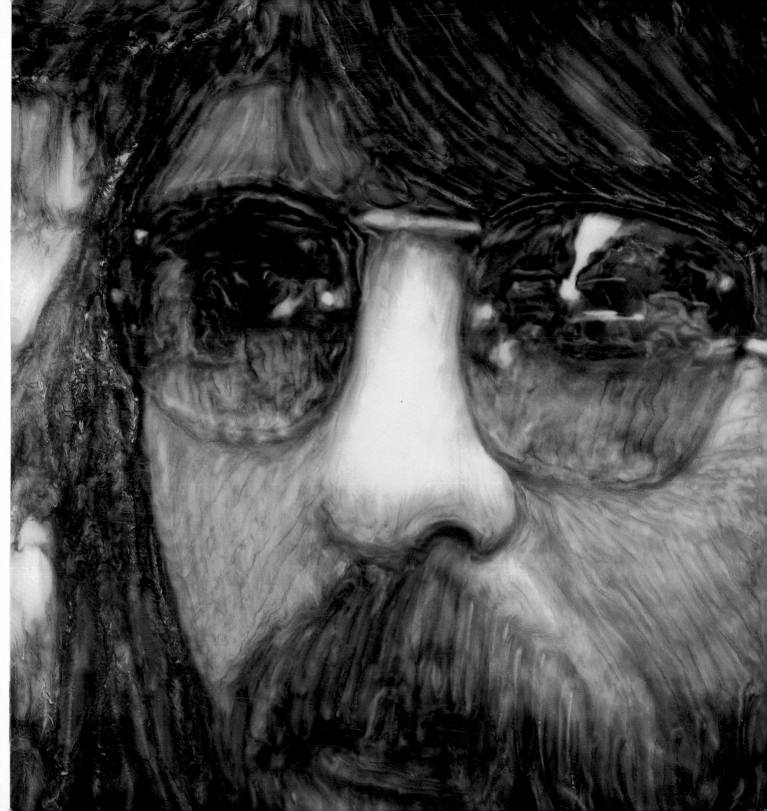

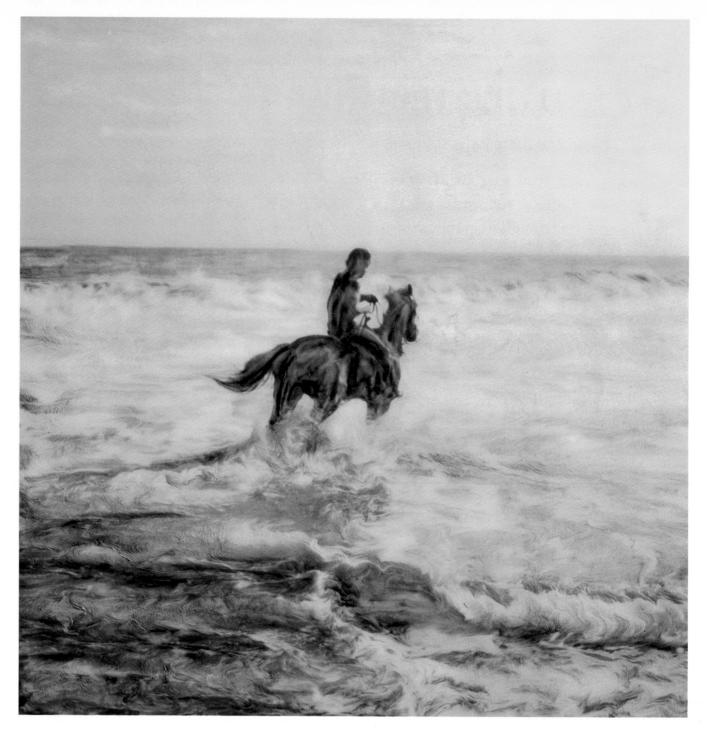

82 **HORSEMAN IN THE SURF** — This magic moment at Malibu is one of my most effective paintings. The high contrast, mysterious rider and the swirling surf with its dark hollows create a strong dramatic effect. Man and horse were lightly traced, while the surf was swirled in its natural lines. The sky was too delicate to paint well.

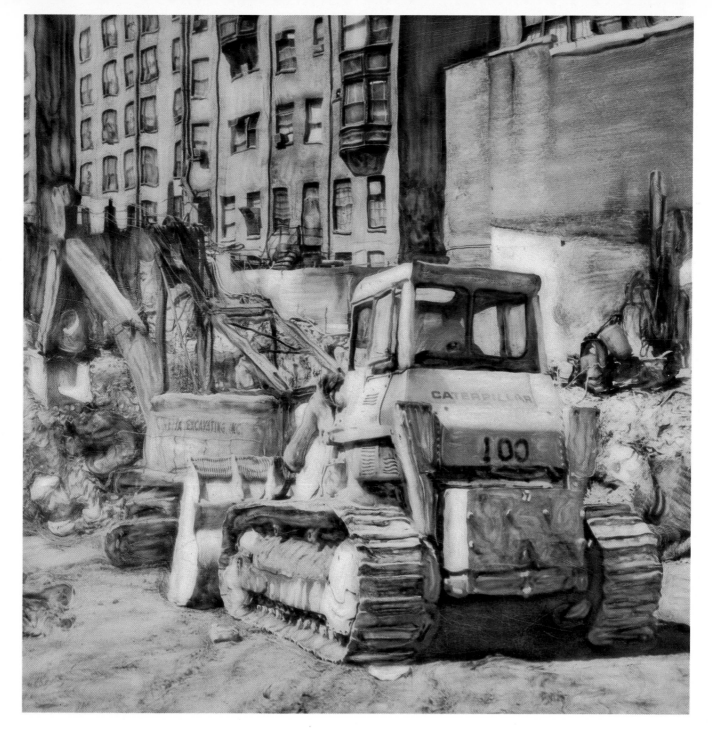

CATERPILLAR — Construction sites may be noisy, but they provide extremely interesting graphic effects. This colorful collection of paintable surfaces, with many shadowed areas for contrast, works very well. A different technique is used for the walls, the Caterpillar and the dirt and debris.

83

BLOW-UPS AND REPRODUCTIONS

Your finished Polaroid paintings can be enlarged and mounted just the same as regular prints. Polaroid will copy them, and even though you might get more perfect color reproduction from a professional photo lab in your city, Polaroid does have the best prices and will provide completely acceptable copies and blow-ups. Information is provided with each film pack. Often, there are special offers for discount on quantity orders, or special sizes. It is wise to inquire by phone or mail, at the nearest Polaroid processing center.

Although "painted" art becomes more dramatic as the "painting" is enlarged, it is well to remember that the larger the print, the greater the loss of color. On the other hand, since the painting effect is greater, one must be weighed against the other. Bear in mind also that though some paintings improve in overall effect when blown up, others can lose something. There is no way to be sure. It is probably best to try a less expensive 5" x 5" first, then go larger if that works well. As with so many other Polaroid painting techniques, the key word here is: EXPERIMENT. One other important point to remember: If your original Polaroid painting has good brush strokes it will usually blow up well.

THE POLAROID XEROX

You can also produce extremely interesting results (and inexpensive copies) through another amazing new technology. By blowing up your originals to 8" x 8" and duplicating them on a Xerox color copier, you can achieve truly unpredictable and exciting results. Details get lost, tones shift, feelings change. (Page 94 .)

If you live close enough to a four-color Xerox machine, an entire new range of possibilities exists. Luckily, the T-shirt boom has created many new shops which have such machines. Although T-shirts cost around $8, reproduction on paper should run around 50 to 75 cents.

Be friendly with the Xerox operator. If you can get him or her to vary the color settings, you can produce copies in monotones of blue, red or yellow, or duotones of various combinations. Try mixing and matching. Combine two or three colors in varying proportions for a new color and effect each time. If you can afford it, try them all. They look great in combinations or series.

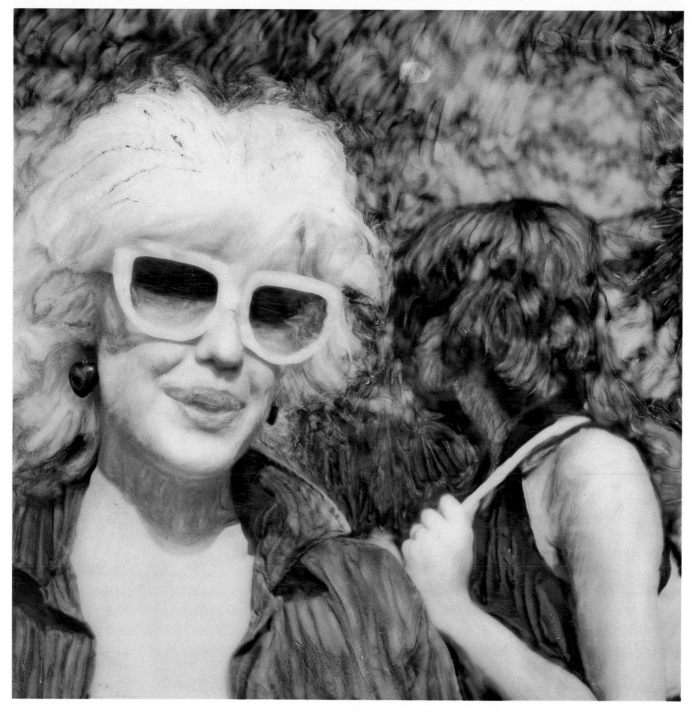

CYRINDA FOXE — Most surfaces in this photo, like the hair and sunglasses, were exaggerated to begin with. Slight alterations made her look larger than life. Her lips also broadened nicely. The out-of-focus background was accomplished by a stabbing, van Gogh effect. The combination of strokes works well.

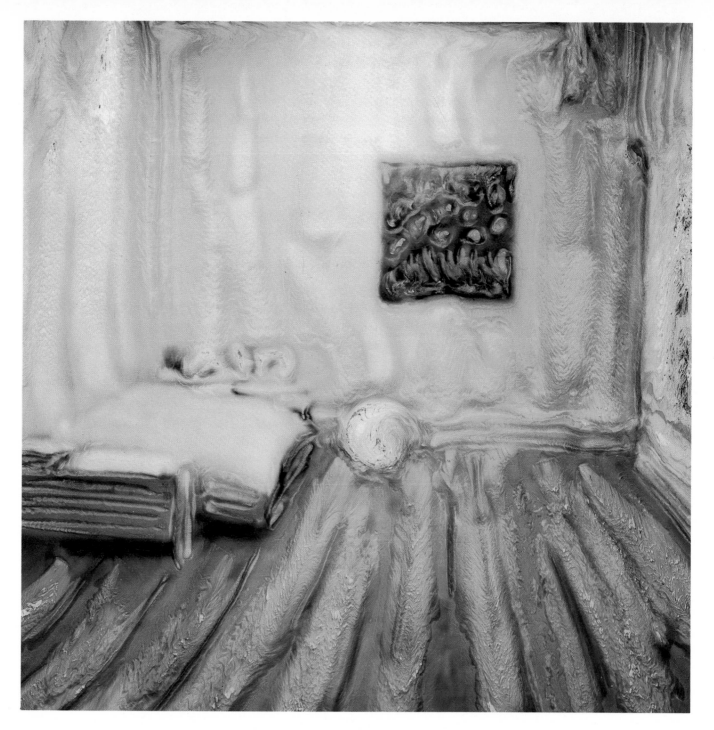

THE STUDIO — One of my first palette knife efforts, this was my New York studio with its white sofa, blond wood floor and lamp. Flat strokes, using the side of the stylus, pushed the paint easily. In the flat areas, I worked broadly. The lamp, sofa, table and the painting were manipulated very deliberately.

INSTANT EXPRESSION

As you paint your Polaroid photographs, you will continually experiment with form, color, relationship, contrasts, juxtapositions. Each Polaroid print can provide unlimited situations. Each creation presents hundreds of visual decisions. Practice in making these decisions, and seeing the results of the decision immediately upon making it, can be easily crammed into your collection of visual skills.

Another great advantage of Polaroid painting is that if you make a mistake or a bad visual decision, you can often correct it immediately. The act of correction is also an important part of the learning experience.

Real pleasure can be obtained from the act of Polaroid painting. The ease of expression and the immediately satisfying results make it fun to do and, therefore, fun to practice. Practice may not make you perfect but it will make you better and more creative.

BE YOUR OWN MODEL

SHOOTING YOURSELF — THE PHOTOGRAPHER AS MODEL

One of my most common subjects has been myself — for several reasons: I'm always around, I work cheap and I am usually in perfect agreement with the concept of the shot. Also, if I don't like the painting, it becomes a nice snapshot to save because it's still a picture of me and not a bowl of fruit.

Self-portraits are best made by shooting the camera with your thumb. Pre-focus for distance; that is, focus the camera to the tip of your extended hand. Then, holding the camera in your outstretched hand, it will be properly focused on your face.

For this kind of close-up portrait, you should choose an attractive background. You can even compose, a little bit, by looking at your reflection on the face of the lens.

With a remote cord or time unit you can also shoot medium and long shots, although I feel close-ups provide the best results.

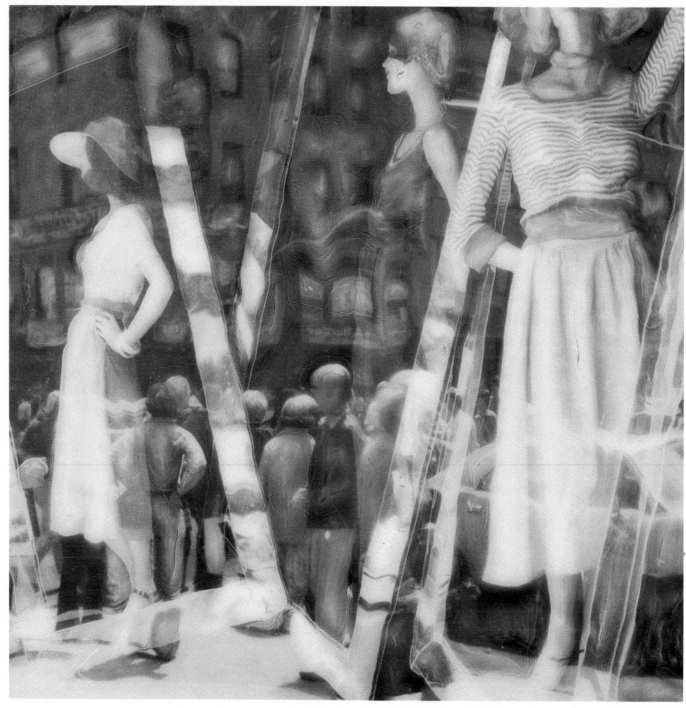

MANNEQUIN - This is a complex photograph, dealing with mirrors behind reflective glass
and people and poses on both sides of the windows. Each small section of this painting
could have been taken in many directions and different effects obtained.

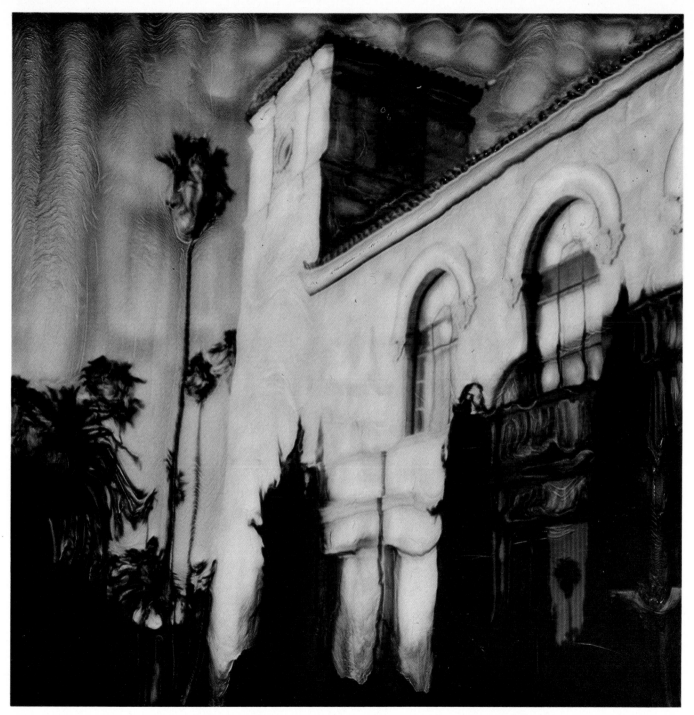

HOLLYWOOD MEMORIAL — The church tower is a common subject for painters and photographers and there are lots of them around. The warm sun adds richness and the high contrast lends to paintability. Note, one window remains photographic.

A FEW SIMPLE TIPS

You'll find your own creativity coming to the fore more easily if you follow the simple tricks listed below. First, clearly define your problem, subject, situation or opportunity. Then, mentally, systematically:

1. Turn it around. All the way around. See it from the other side.

2. Turn it inside out. See it from the inside.

3. Turn it upside down. See it from below.

4. If it's black, make it white or transparent.

5. If it's white, try it black or in stone.

6. If it's black and white, try colors.

7. If it's small, do it grandly.

8. If it's big, try it lightly.

9. If it's fast, do it slow.

10. If it's slow, try it fast.

11. If it's pieces, see the whole.

12. If it's whole, check the parts.

13. Examine each part and then start at it again.

Practice thinking this way and after a while you'll be amazed at how creative you've become.

Remember: Practice is as important in Polaroid painting as it is in any other learning process. Even though the basic technique is simple, to achieve true "art," you need experience. And DON'T BE AFRAID TO EXPERIMENT!

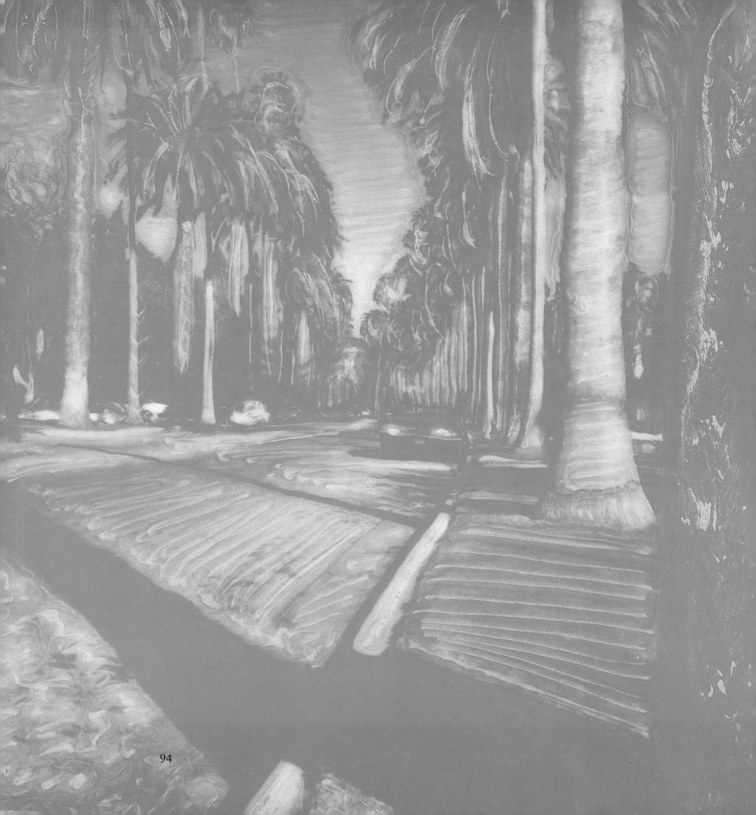

SUGGESTED READING AND VIEWING

If you want to add another dimension to your creativity practice, expose yourself to the art of the great oil painters. See their work in as many aspects as possible but try to see what it is that they "turned around" to create their masterpieces. What did your favorite painter turn around or inside out? What did the French Impressionists actually do? Or perhaps more important, what didn't they do? Define it in your own words and see what you're saying. Apply those thoughts and words and see how it translates to you and your own creation.

ONE LAST THOUGHT

May I suggest that, as soon as possible, you shoot and paint at least one pack of SX-70 film — ten shots.

Then read this book again.

PRICE/STERN/SLOAN
Publishers, Inc., Los Angeles